Cute Cats
DOT to DOT

by Christina Rose

Cute Cats Dot to Dot
Adorable Images and Scenes to Complete and Colour

First published in the United Kingdom in 2016 by
Bell & Mackenzie Publishing Limited

ISBN: 978-1-911219-01-9

Printed and Bound in Great Britain by TJ International Ltd.

Created by Christina Rose

www.bellmackenzie.com

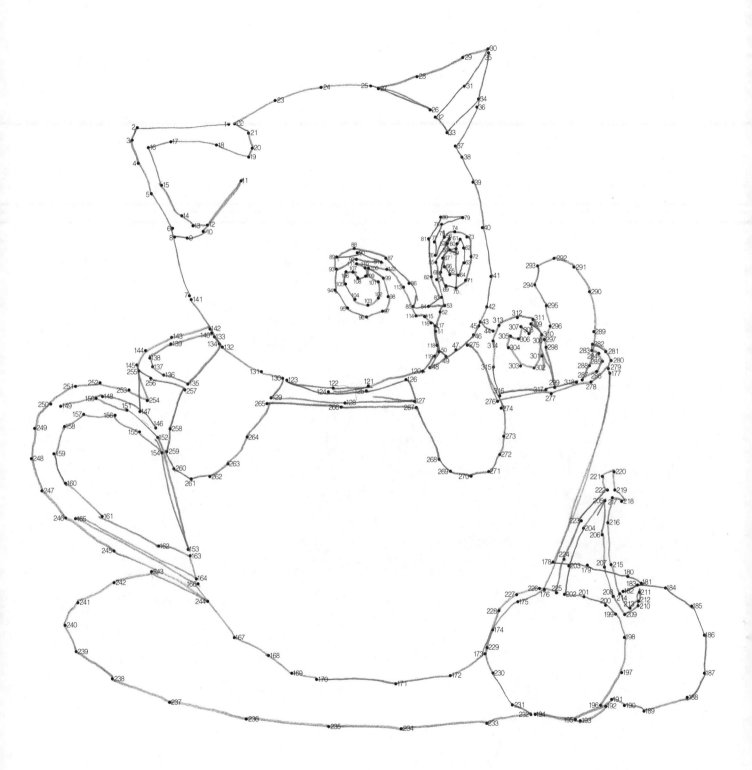

1-318

323

1-561

510

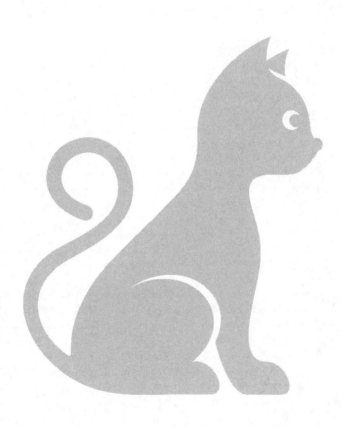

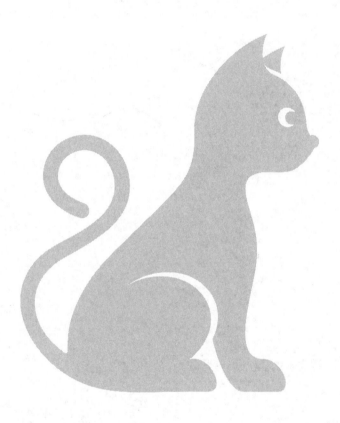

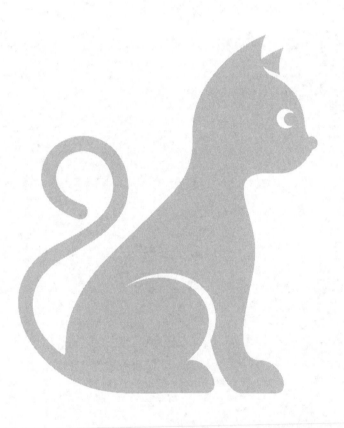

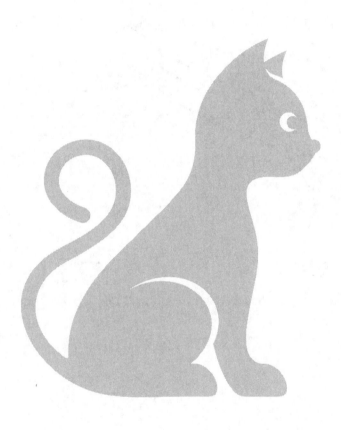

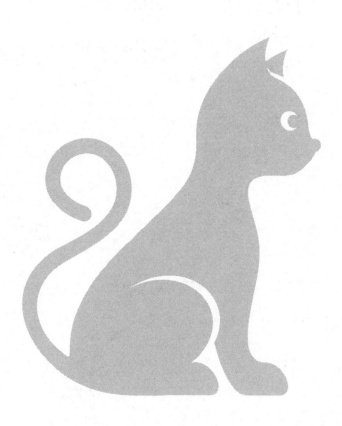

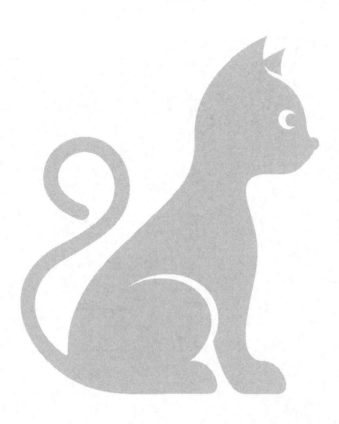

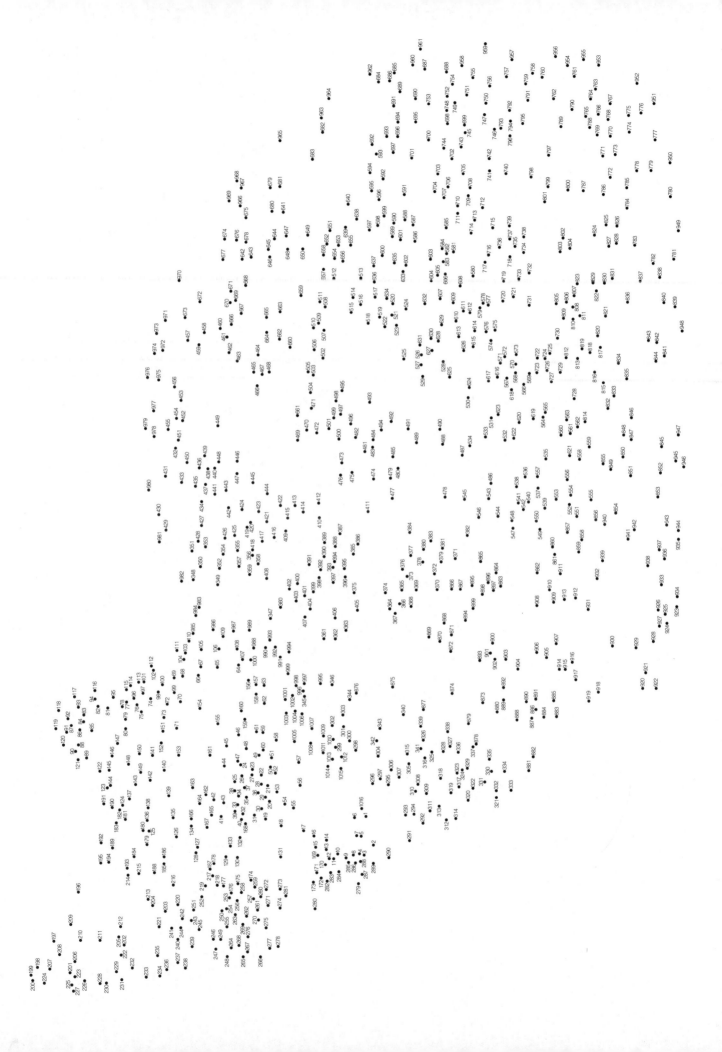

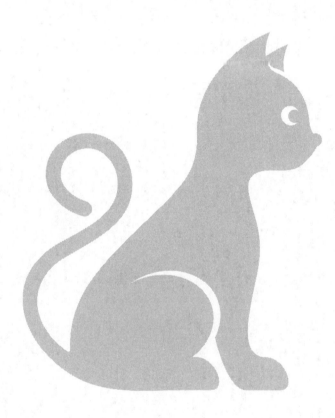

429

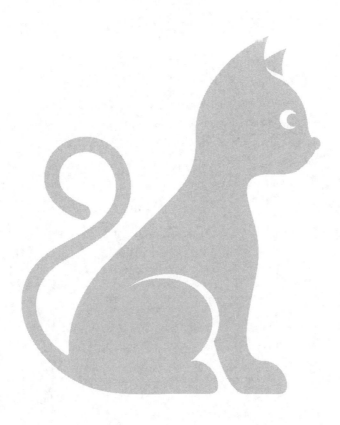

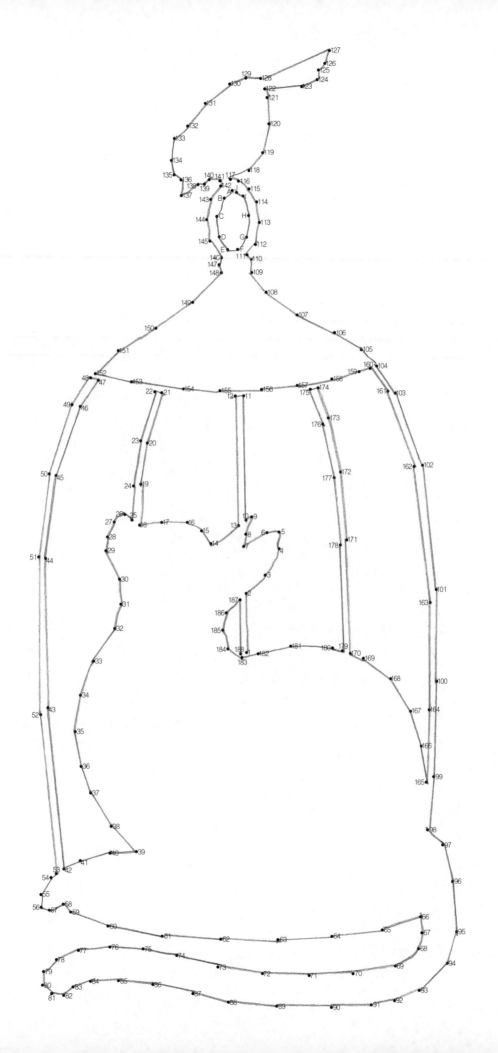

1-188

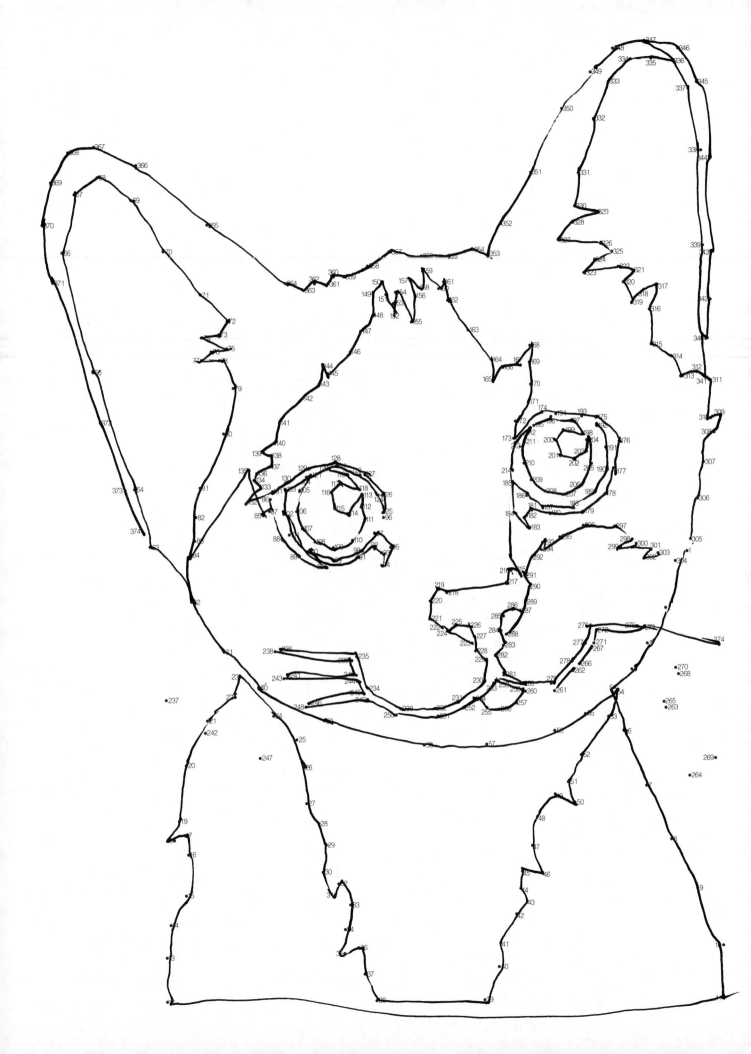

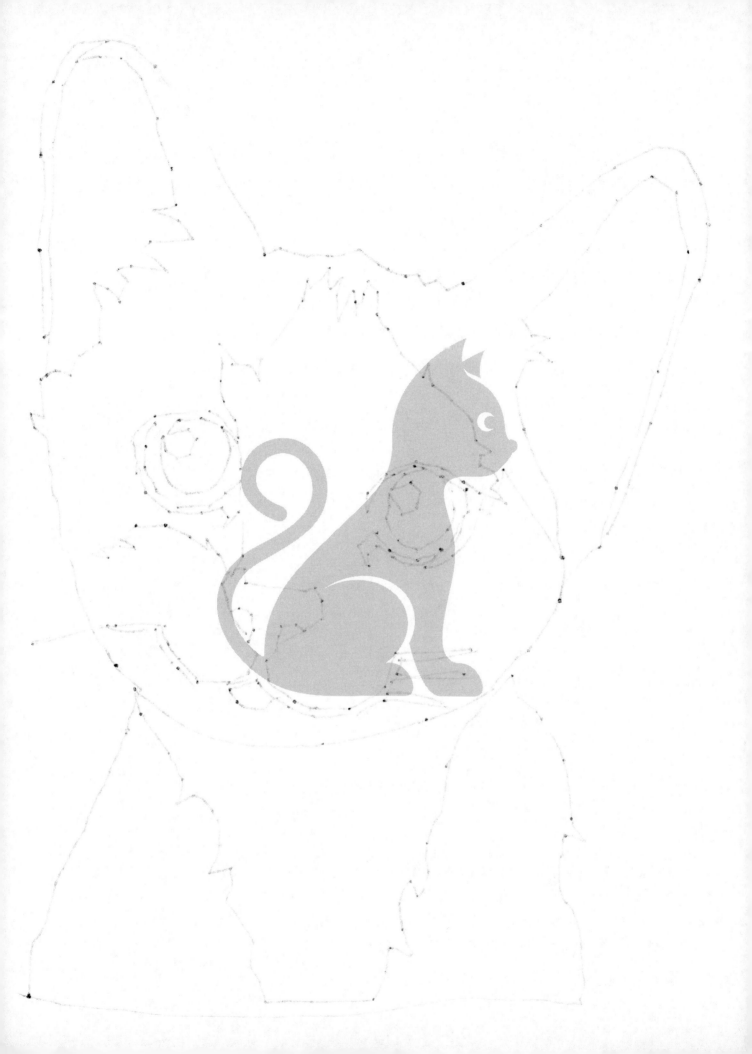

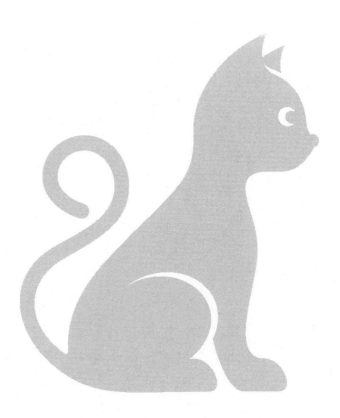

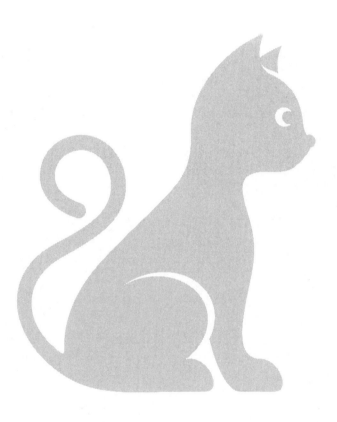

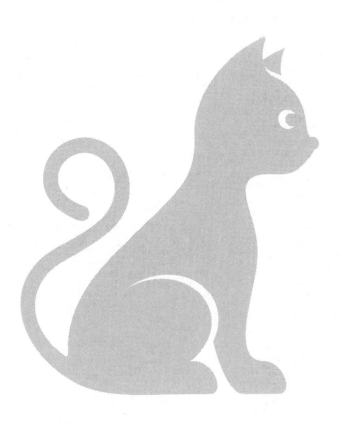

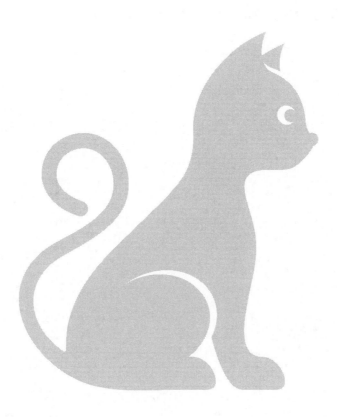

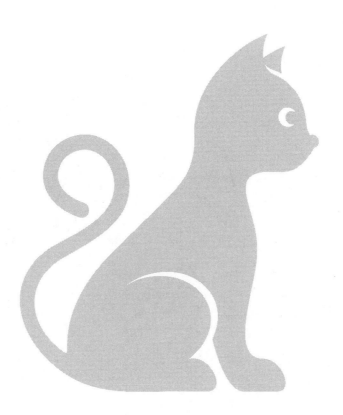

384

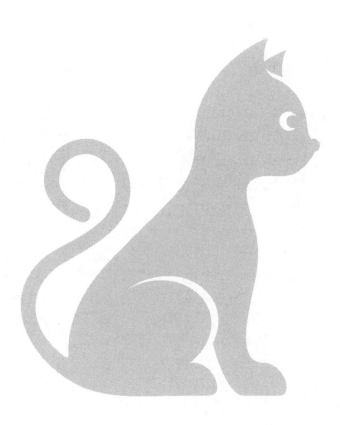

665

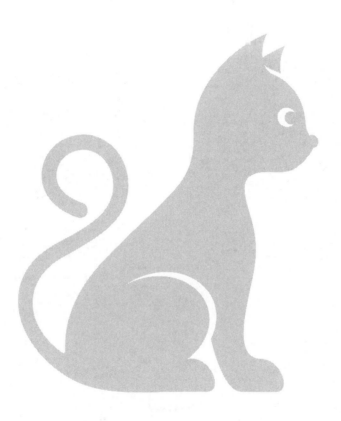

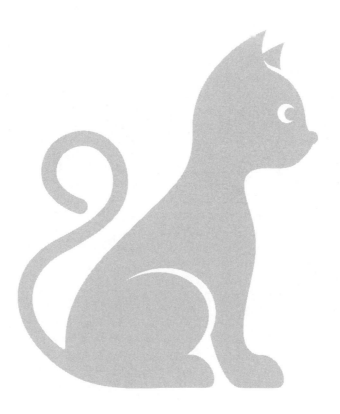

1-376